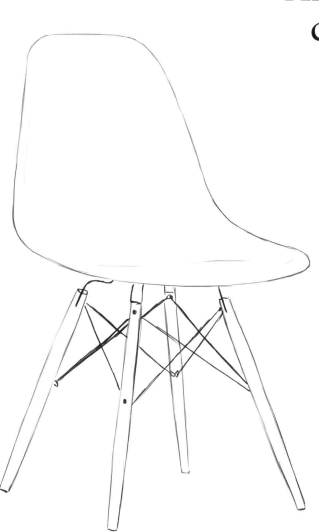

Are you sitting comfortably?

Then let's begin.

What:
Wassily

Who:
Marcel Breuer

When:
1925

One of my favourite chairs in this colouring book and the one I would most like in my house. The frame is made from bent tubular steel and the seat, back, and armrests are formed by stretched pieces of canvas or leather. Whilst the frame design is fairly complicated, the comfortable bits are incredibly simple. I would like the tan leather one please.

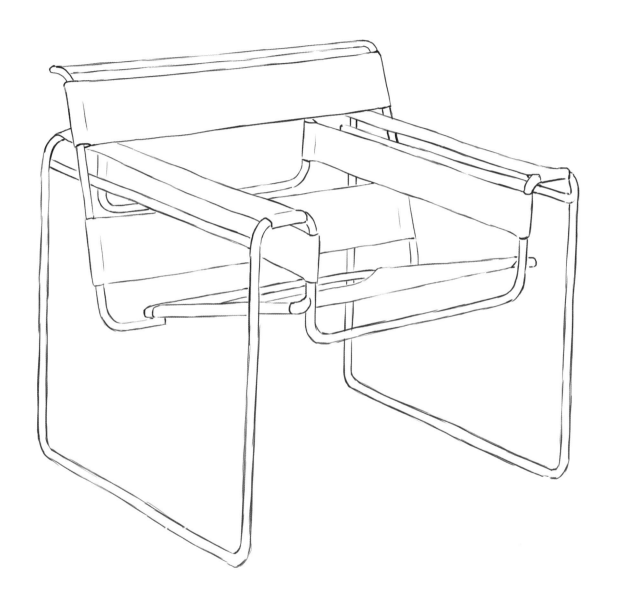

What:
Louis Ghost

Who:
Philippe Starck

When:
2002

Philippe Starck is the king of irony when it comes to furniture design. This chair is reminiscent of the opulent times of Louis the Fourteenth but is made using single injection- moulding in clear acrylic. This chair is great to look at, affordable, comfortable, durable inside and out, and can be stacked 6 high! 10/10 Philippe!

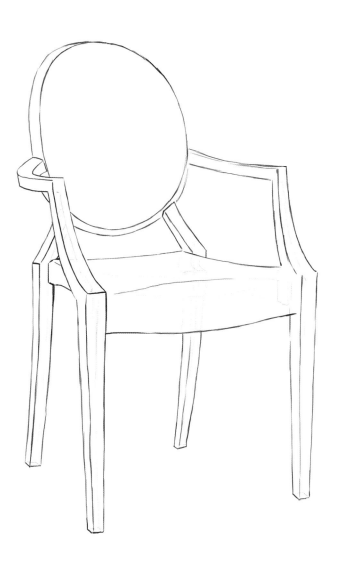

What:
Model No. 670

Who:
Charles & Ray Eames

When:
1956

If you're a stylish man in the late 1950's, you will need a sharp suit, a packet of Lucky Strikes, a glass of something on the rocks... and one of these chairs.

This chair was at the height of luxury when it first came to market and is the most complex in terms of construction. The framework is made from separate pieces of moulded plywood that are then veneered in rosewood. Upon this are seated large, full leather buttoned cushions. This chair also comes with a footstool entitled Model No. 671.

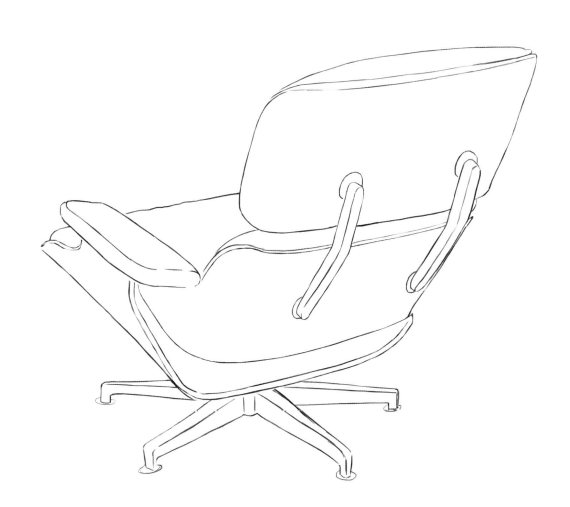

What:
Y Chair
AKA 'Wishbone'

Who:
Hans Wegner

When:
1950

Ahhh how we dream of these around our 10 foot dining table whilst flicking through *Elle Decoration*. This chair has been incredibly popular over recent years and its classic, traditional design is most probably why. Wegner has been described as the "chair-maker of chair-makers" and this elegant design is enough to see why.

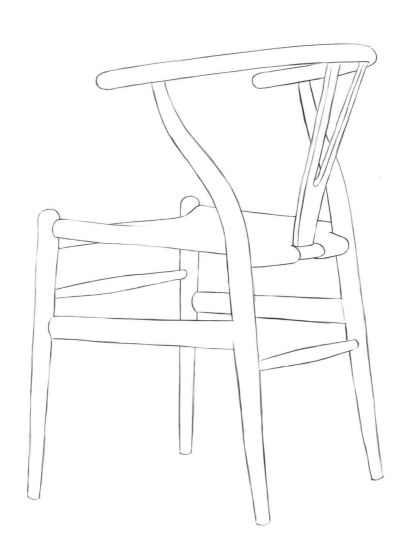

What:
Royal Festival Hall Lounge Chair

Who:
Robin Day

When:
1951

This chair was designed for The Festival of
Britain in 1951. This is the lower, more relaxed
and comfortable version of its matching dining
chair. It is made from mahogany veneer and
the seat is upholstered in a woven plastic
called 'Tygan'.

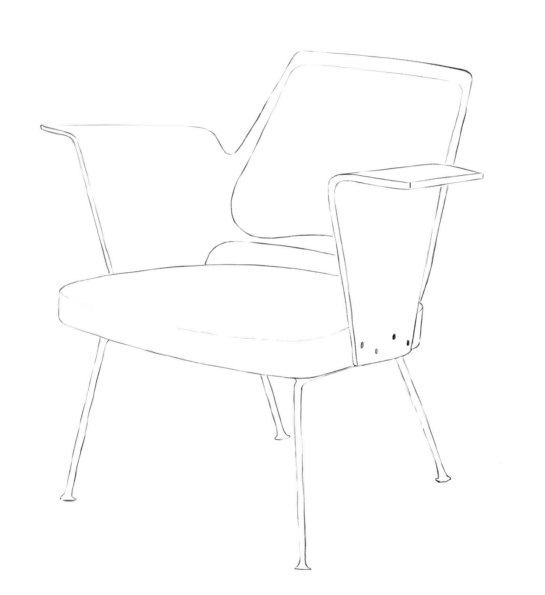

What:
Panton

Who:
Verner Panton

When:
1959

This innovative (in its day) chair was made
from one singular piece of injection-moulded
plastic. Popular with café bars, it is extremely
durable and completely stackable (although
its complicated shape leads you to think
otherwise).

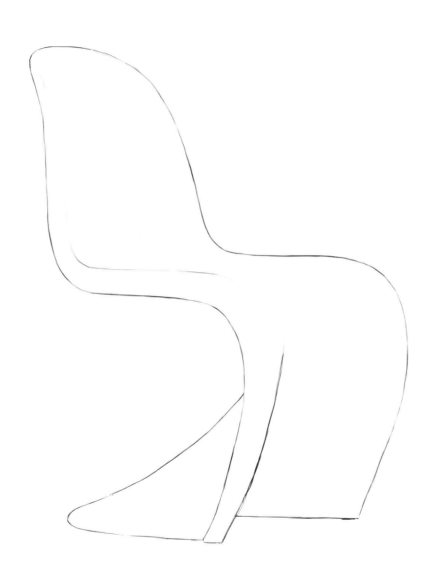

What:
Tulip

Who:
Eero Saarinen

When:
1955

This chair has an aluminium base that is cast in plastic. The seat is moulded fiberglass with a loose upholstered cushion... Usually in orange. It is often seen in old movies when they are going for a "futuristic" vibe. Groovy.

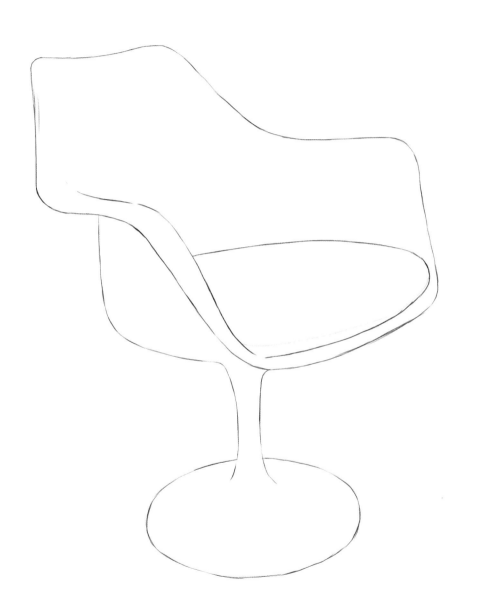

What:
RAR (Rocking Armchair Rod)

Who:
Charles & Ray Eames

When:
1948

A few years ago, these were desired from afar upon the pages of *Elle Decoration*. Now (thanks to some cheap knock-offs), they are being rocked by everyone, their kids and their dogs. The original, which is still available and highly popular, comes in moulded fiberglass, with metal rods and birch rockers.

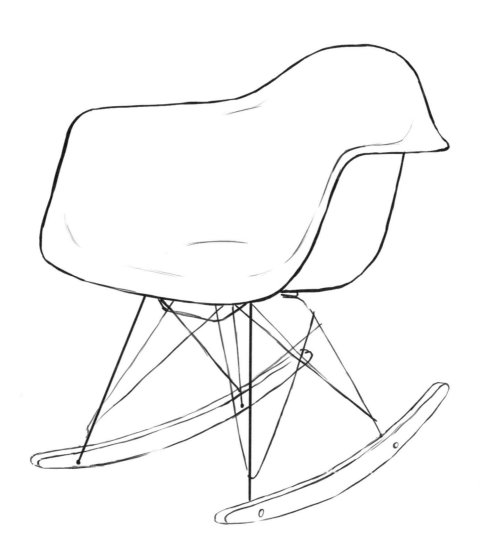

What:
Egg

Who:
Arne Jacobsen

When:
1957-1958

If I am ever to become an evil dictator, I will
be sitting in one of these while I go about my
business. It is made from a fiberglass shell,
covered in foam and fabric upholstery, with
steel base and feet. You can swivel in it, what
more do you want?

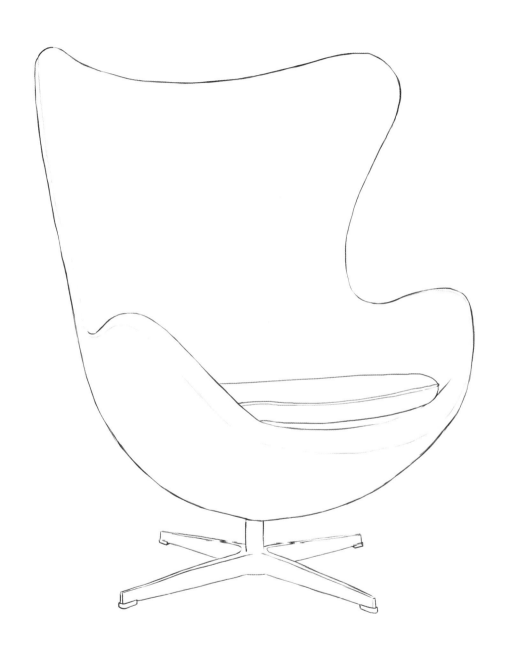

What:
LCW

Who:
Charles & Ray Eames

When:
1945

This chair is delightful. It is made from birch-veneered plywood, moulded to fit the human posterior and lower back. Simple, understated, gorgeous.

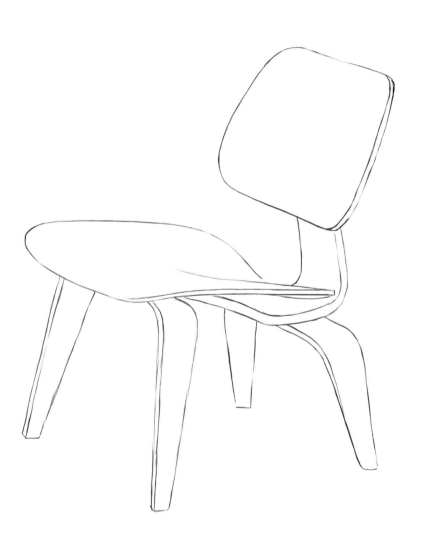

What:
Armchair, Model B64

Who:
Marcel Breuer

When:
1928

Nicknamed the 'cantilever chair', this steel-framed chair features cane seats and is becoming increasingly popular around hipster dining tables.

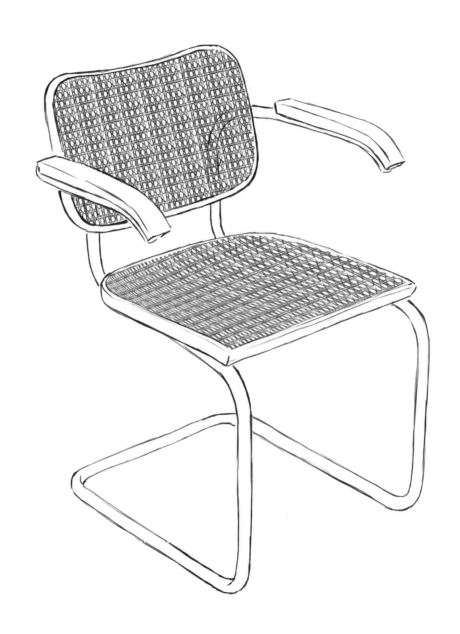

What:
Polypropylene - Series E

Who:
Robin Day

When:
1971

You will most likely recognise this popular chair from your school days, or from a meeting in your local village hall. These chairs, first developed by Day in 1963 are made from a tubular steel frame, with a comfortable moulded plastic shell. There are several versions of this chair: some with a fabric seat pad, some with back openings. But all of them, incredibly durable and timeless.

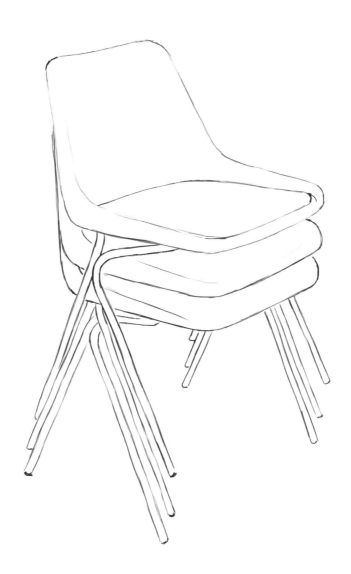

What:
La Chaise

Who:
Charles & Ray Eames

When:
1948

I don't know about you but this chair reminds me of a fried egg and despite its crazy appearance, it is actually incredibly ergonomic. It was designed for the Museum of Modern Art as a submission for a low-cost furniture competition. However, with its fiberglass shell, wooden and steel frame, it proved to be far from low-cost!

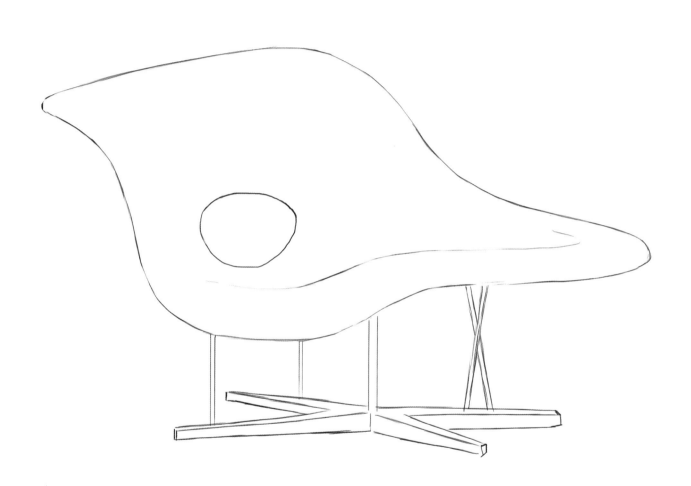

What:
Tolix

Who:
Xavier Pauchard

When:
1927

Made from hardy galvanized steel, this chair is popular with café bars as it can be used inside, outside and in all weather conditions. It comes in a variety of cheerful colours and looks great as an industrial piece or as an addition to a farmhouse kitchen. Jack of all trades this chair is!

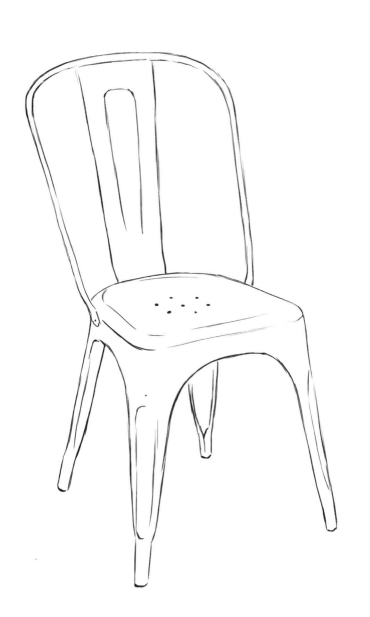

What:
Barcelona Chair

Who:
Mies van der Rohe

When:
1929

A stunning chair, designed to be used in the German Pavilion for the International Exhibition Barcelona.

This was originally made from a curved and flattened steel frame, and had a luxurious buttoned-leather seat and backrest strapped to it. A staple chair for swanky designer waiting rooms, it is often accompanied by its matching foot stool.

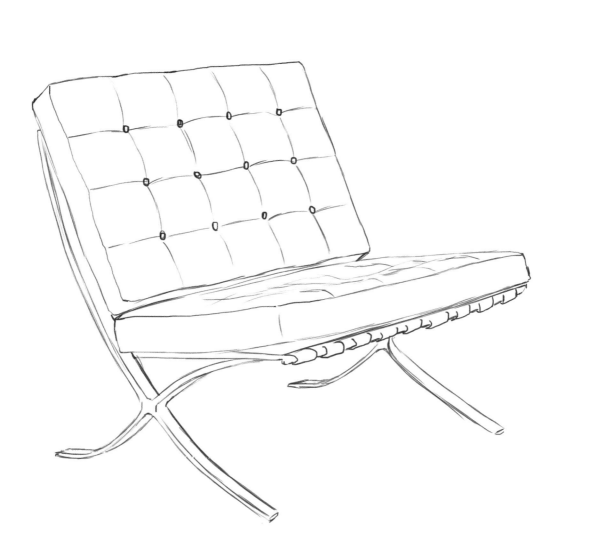

What:
Grand Comfort

Who:
Le Corbusier & Charlotte Perriand

When:
1928

Big, comfy, stylish, what more do you want in a chair? (Apart from a glass of wine and a bit of Camembert to nibble on of course.) The external steel frame shimmers against the sumptuous leather, making this (though slightly unaffordable for most) a design classic.

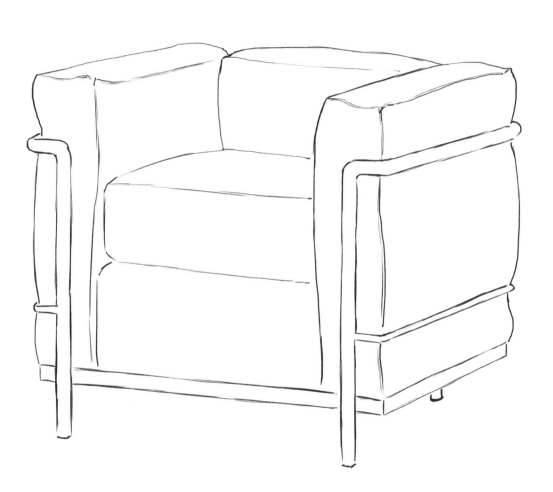

What:
Red/Blue Chair

Who:
Gerrit Rietveld

When:
1918

Part of the De Stijl design movement, this chair looked incredibly modern for its day. Made from beechwood and plywood and lacquered in bright, primary colours, you can't help but think that Rietveld had a time machine that took him to the 1980's before he designed this. It's totally rad.

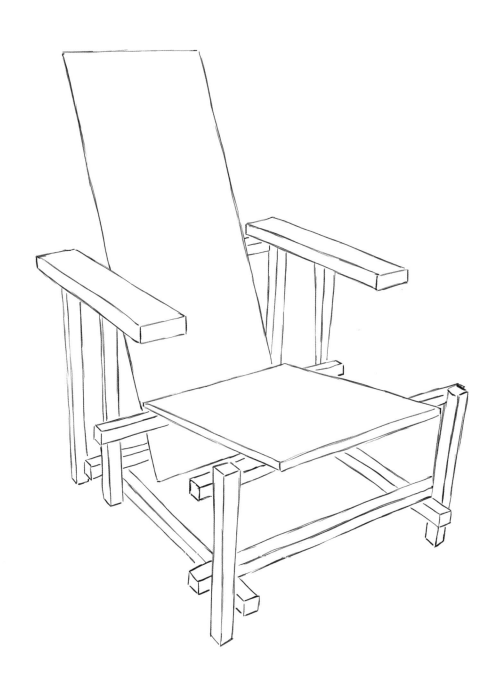

Don't forget to show me your colouring efforts!
Twitter: @mellyelliott
Instagram: @i_love_mel
Facebook: ilovemelofficial

First published in the United Kingdom by I LOVE MEL
6th Floor, Cavendish House
Hastings
East Sussex
TN34 3AA

I LOVE MEL is a trading name of Brolly Associates Ltd.

ISBN 9780992854416

10 9 8 7 6 5 4 3 2 3

Printed by CMYK, LONDON.

This book can be ordered direct from the publisher at
www.ilovemel.me

Distributed in the UK and Europe by Turnaround
orders@turnaround-uk.com